THE Love STORIES ·OF· THE BIBLE Speak

COLORING BOOK

ALSO BY SHANNON BREAM

Finding the Bright Side

The Women of the Bible Speak

The Mothers and Daughters of the Bible Speak

The Love Stories of the Bible Speak

The Women of the Bible Speak Coloring Book

The Women of the Bible Speak Workbook

The Mothers and Daughters of the Bible Speak Workbook

The Love Stories of the Bible Speak Workbook

THE Love STORIES · OF · THE BIBLE Speak

COLORING BOOK

Color and Contemplate

SHANNON BREAM

FOX NEWS books

WELCOME

God is not just the author of love; He is love, and all true love is rooted in Him. God's love is perfect, unblemished, and unconditional. Even more amazing, nothing can separate us from that love. You can't do anything to earn God's love, and no one can take it away from you. God's love never fades away.

Throughout the pages of Scripture, we discover all kinds of love stories. There's the original bond between Adam and Eve, the loving respect between Ruth and Boaz, and the unexpected encounter between David and Abigail. There's the surprise news for Joseph and Mary, the risky request of Esther to King Xerxes, and the passionate love between Solomon and the Shulammite woman. Through their stories, we gain wisdom and insight into selfless love, sacrificial love, and life-changing love.

But not all love is romantic. Today, Western culture tends to emphasize romantic love above all others. Yet, in the ancient world, those priorities were reversed. Friendships were often seen as the most treasured of relationships. Marriages carried the weight of obligation, whereas friendships carried the freedom of choice. Through the fellowships of Job and his friends, Paul and his friends, and Jesus and His friends, among many others, we see how the bonds between friends can encourage and equip us for life and faith.

Together, the love stories of the Bible offer inspiration and wisdom for all of our relationships. Some offer sharp warnings while others provide beautiful examples of what it looks like to love well. Each one invites us to grow into healthier, stronger people who can serve and love others as God intends.

SONG OF SONGS

Take me away with you—let us hurry!
Let the king bring me into his chambers.

SONG OF SONGS 1:4

Solomon, renowned for his wisdom and credited with composing over 1,000 songs, pens a love ballad that surpasses them all. This masterpiece, believed to be both written by and about King Solomon and his bride, a Shulammite woman, contains intense, heart-felt poetry that captures some of the most vibrant expressions of love and devotion ever written in the ancient world. Some ancient scholars deemed the content too sensual for the easily tempted.

The book illuminates God's blueprint for romance, love, and intimacy. Though the passionate couple yearn to be together, they provide a beautiful model of abiding by healthy boundaries that keep them apart until the proper time.

The principles woven throughout this romantic book
stand in such stark contrast to much of what modern society
tells us about relationships.

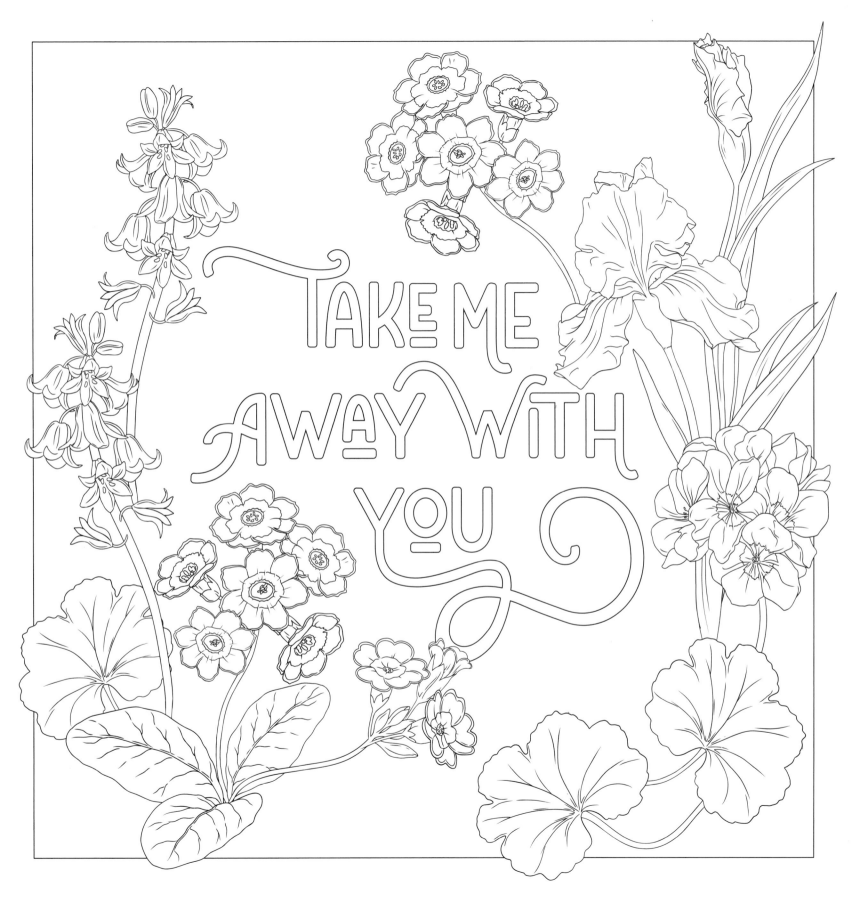

THE BRIDE

I am a rose of Sharon,
a lily of the valleys.

SONG OF SONGS 2:1

The bride of Solomon is never named, and only known as the Shulammite woman. She fearlessly expresses her passion for her soon-to-be husband. In the second chapter, the bride humbly refers to herself as "a rose of Sharon, a lily of the valleys" (Songs 2:1). These flowers, with their delicate petals, were plentiful. Through the love that has blossomed between the couple, the bride's own beauty has flourished: that's the power of speaking life over each other.

The power of words between spouses cannot be underestimated. Even in the midst of heated arguments or frustrations, it is crucial to be mindful of the language we use toward our beloved, for words have the power to wound and scar or breathe hope, beauty, and confidence.

Solomon and his bride show us the beauty
of lavishing each other with positive reinforcement.

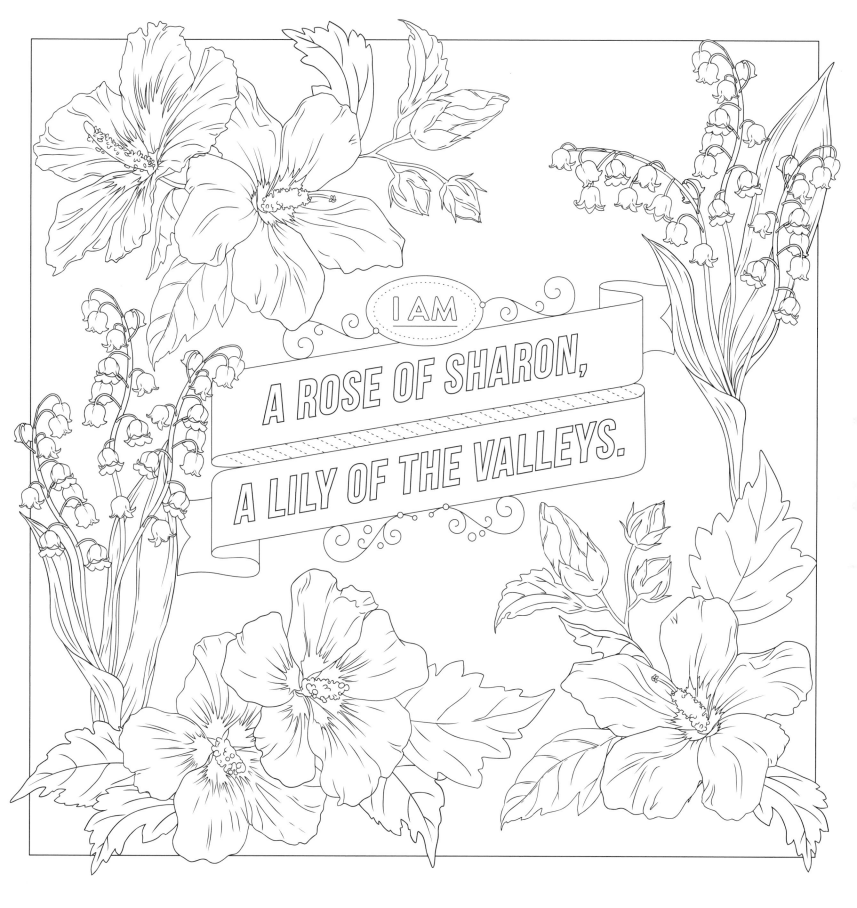

I AM

A ROSE OF SHARON,

A LILY OF THE VALLEYS.

THE GROOM

If you do not know, most beautiful of women,
follow the tracks of the sheep and graze your young
goats by the tents of the shepherds.

SONG OF SONGS 1:8

King Solomon is best known for his wisdom and wealth. Yet one of the lesser-known aspects of his life is his passionate love for the Shulammite woman. Song of Songs opens with the woman's desire for him described in great detail. Solomon doesn't hesitate to return the love and describes her as the "most beautiful" woman in the world (Songs 1:8). But the couple's affections aren't just physical; they are emotional and spiritual. Solomon describes his lover as "a garden locked up . . . a spring enclosed, a sealed fountain" (Songs 4:12). He cherishes her and protects her, for he knows their love, like all love, is a precious and valuable gift that should be protected at all costs.

This bride and groom remind us just how powerful and precious love
and the hope for a lifetime bond can be.

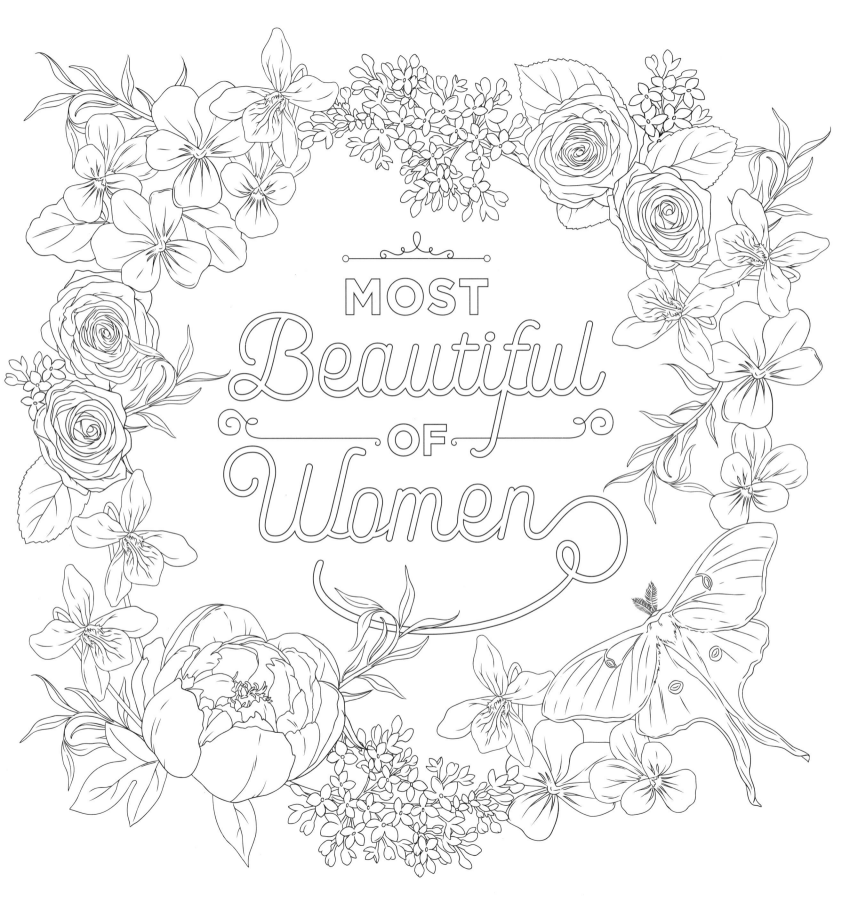

MOST
Beautiful
OF
Women

THE STRENGTH OF LOVE

Place me like a seal over your heart, like a seal on your arm; for love is as strong as death, its jealousy unyielding as the grave. It burns like blazing fire, like a mighty flame.

SONG OF SONGS 8:6

❋

Toward the end of this all-time great love song, the bride asks the groom to place her as a seal over his heart and on his arm. She says, "love is as strong as death" (Songs 8:6). This speaks to the permanence of the relationship. It's crucial to tend to love, marriage, and our spouses. We must prioritize the needs of the other person and what's best for them, not just our own selfish desires. And we must resist the temptation to allow our relationships to operate on autopilot.

Though we may not be as skilled in poetry as the writer of the Song of Solomon, something as simple as tucking a small note on your spouse's bedside table or cooking their favorite meal can make a huge impact. Instead of always trying to be right, why not strive for peace? Because when you both give 100 percent, everyone wins.

When you're busy trying to put the other person first, you both wind up happy.

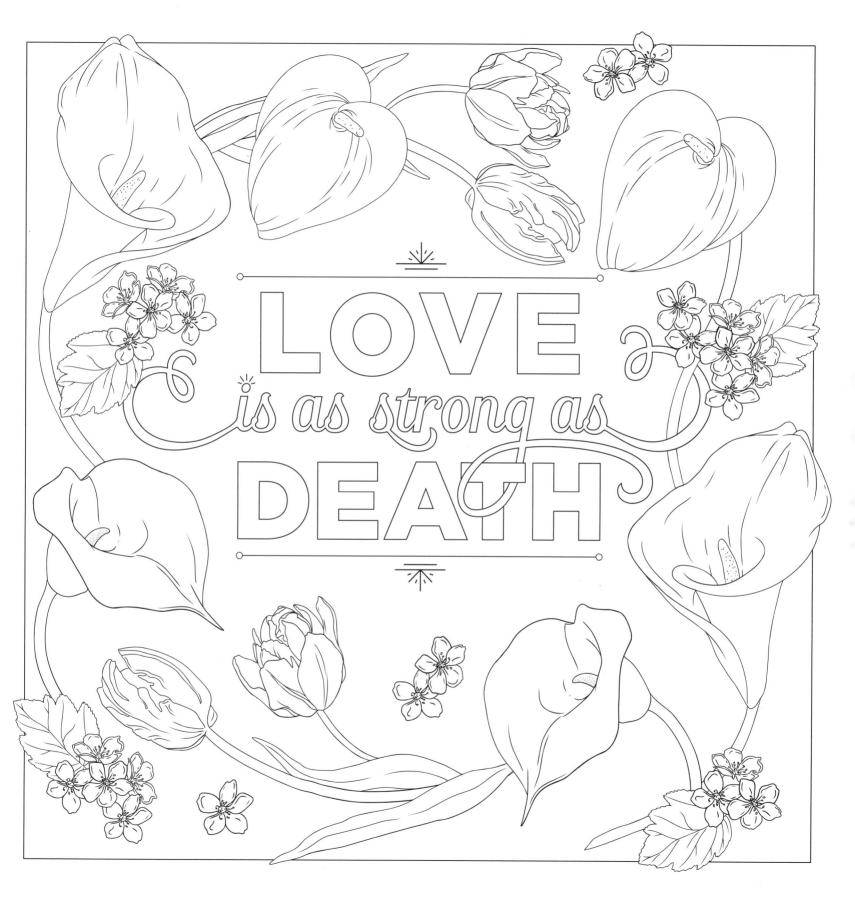

MANOAH AND HIS WIFE

Then Manoah prayed to the Lord: "Pardon your servant, Lord. I beg you to let the man of God you sent to us come again to teach us how to bring up the boy who is to be born."

JUDGES 13:8

Manoah's wife, childless for years, is visited by an angel who promises her a son who will deliver Israel from the Philistines. The angel instructs her with guidelines for her pregnancy and the child's life, including abstaining from wine, any unclean foods, and never cutting his hair. When she tells her husband, they're united as a team. Manoah prays, "Let the man of God you sent to us come again to teach us how to bring up the boy who is to be born" (Judges 13:8). God answers the prayer, and soon they are the parents of Samson, who becomes a mighty warrior. Devoted to God and each other, this couple provides a beautiful example of a healthy marriage in which both partners are on the same team.

Manoah wanted to be sure they got this right as parents who would work together on a glorious assignment.

SAMSON

Some time later, he fell in love with a woman in the Valley of Sorek whose name was Delilah.

JUDGES 16:4

Manoah and his wife's son, Samson, grows to become a mighty warrior and leader, but he has a weakness for women. Before he meets Delilah, he sleeps with a prostitute and marries a Philistine who doesn't worship God. Following the failed marriage, Samson "fell in love" with Delilah (Judges 16:4), a woman who would soon betray him.

If a person moves from one flawed relationship to another, it is important to consider what deep-seated emptiness they may be attempting to fill. Was Samson longing for a relationship similar to that of his parents? Did he persist in his search, hoping to find a woman who would fulfill him as his mother had done? To flourish in a healthy relationship, we must also reflect on any gaping holes we may be trying to fill and pursue the healing and wholeness that only comes from God.

We, like Samson, take our life experiences into each new relationship.

DELILAH

So Delilah said to Samson, "Tell me the secret of your great strength and how you can be tied up and subdued."

JUDGES 16:6

Every relationship has its struggles, but Samson and Delilah's relationship is destroyed through Delilah's love of money. As their relationship progressed, the Philistine leaders offer Delilah a sum that was like winning a major lottery prize—especially for a woman in the ancient world. With that amount of money, anything was possible. Delilah begs and manipulates Samson in her attempts to discover the secret of his strength. Samson eventually caves, and Delilah uses this information to betray him. Indeed, "the love of money is a root of all kinds of evil" (1 Timothy 6:10), perhaps nowhere more than in our relationships. We must be on our guard against all forms of greed, which can stem from a lack of trust in God—and a lack of trust in our partner, too.

The love of money can be a kind of gluttony, an insatiable appetite rooted in our need to manage our world and everything that happens to us according to our own desires.

THE FIRST COUPLE

That is why a man leaves his father and mother and is united to his wife, and they become one flesh.

GENESIS 2:24

The beginning of human life, the original marriage, and the parents of all humanity start with the first couple: Adam and Eve. Throughout the creation story, God declares what He made good, but when He looks at humanity, He declares it "very good" (Genesis 1:31). Adam and Eve are God's cherished creations in a flawless world overflowing with deep peace and purpose.

The couple stroll with God in the cool of the day, providing a glimpse of true intimacy and vulnerability—physically, emotionally, and spiritually. Though naked, they don't feel any shame (Genesis 2:25). There is nothing to hide from one another or God. The first couple give us a portrait of the unhindered love relationship God intends with us all.

God intended for the relationship between Adam and Eve to be one in which they were partners, perfectly designed to meet each other's needs.

THEY BECOME ONE FLESH

THE FIRST HELPER

The Lord God said, "It is not good for the man to be alone.
I will make a helper suitable for him."

GENESIS 2:18

Soon after Adam is formed, God looks at Adam and says, "It is not good for the man to be alone" (Genesis 2:18). Then God handcrafts a "helper." The first woman was never designed to be an assistant or second-class citizen. In the Hebrew, the word for "helper" is *ezer*, and in almost every instance in the Bible, it's used to describe the rescuing action of God. God uses the very same word for Eve that He uses to describe Himself! God created Eve so Adam could learn and grow alongside her—that, together, they would build a life. And without Eve there would be no Abraham, Isaac, Jacob, or the ultimate savior, Jesus.

Eve was not God's afterthought but an essential part
of her husband's life and of the plan of creation.

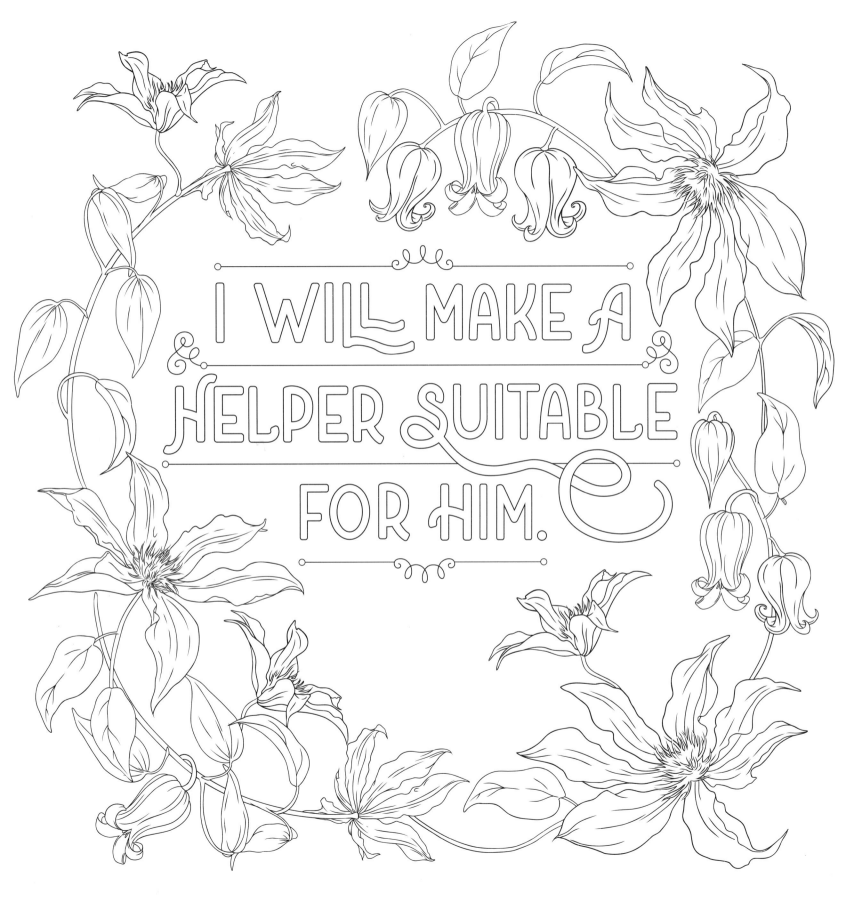

I WILL MAKE A HELPER SUITABLE FOR HIM.

THE FIRST MARRIAGE

Adam made love to his wife again, and she gave birth to a son and named him Seth, saying, "God has granted me another child in place of Abel, since Cain killed him."

GENESIS 4:25

God launches the whole story of salvation, of humanity's journey to God, with a marriage. After a willful act of eating forbidden fruit, Adam and Eve lose access to Eden. Then, after their son Cain murders his brother, Abel, they lose both sons—one to death and the other to separation. Yet, despite the devastation, they keep reaching toward each other, even amid the sorrow. After Adam made love to Eve again, they gave birth to a son named Seth. Their marriage reveals a pattern of togetherness, of serving each other, of rebuilding after terrible events threaten to tear them apart. Through their commitment, thousands of years later, one of their descendants, Jesus, would sacrifice His life to save humanity. Marriage is not an afterthought to Scripture but the foundation of everything else.

Jesus, who was also fully God, would then go on to do what His forefather Adam could not: crush the serpent to save humanity.

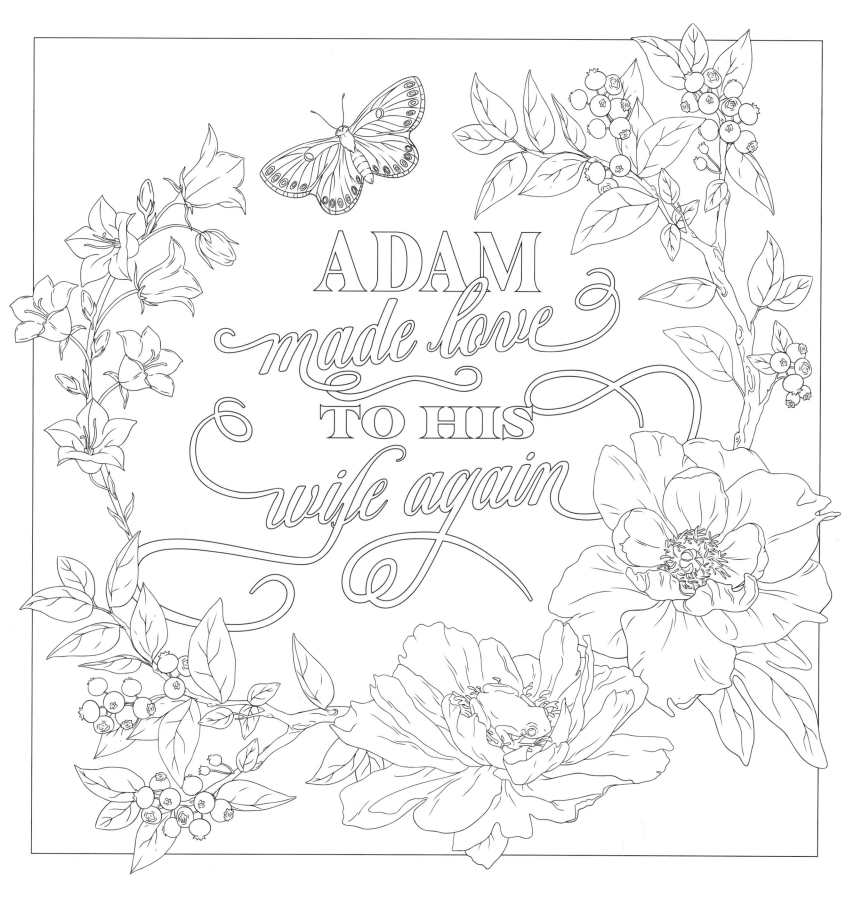

ADAM *made love* TO HIS *wife again*

JOSEPH

"... She will give birth to a son, and you are to give him the name Jesus, because he will save his people from their sins."

MATTHEW 1:21

When Joseph becomes aware that Mary is pregnant, he is likely confused. She is probably in actual danger, as a woman who is considered adulterous or unfaithful could be stoned to death. Joseph responds honorably, with great compassion, and looks to protect Mary by quietly dismissing her rather than publicly disgracing her. That's when an angel of the Lord appears to him in a dream and assures him Mary has conceived by the power of the Holy Spirit, quelling Joseph's fears about marrying her. Because of Joseph's faithfulness, he got to name the Son of God, Jesus.

One of the most loving actions we can take toward others is resisting the impulse to retaliate or publicly shame someone else. Instead, like Joseph, we can pursue a response that honors God and those we love.

God knew Joseph would be an earthly father to His Son and made sure he was also divinely guided and comforted.

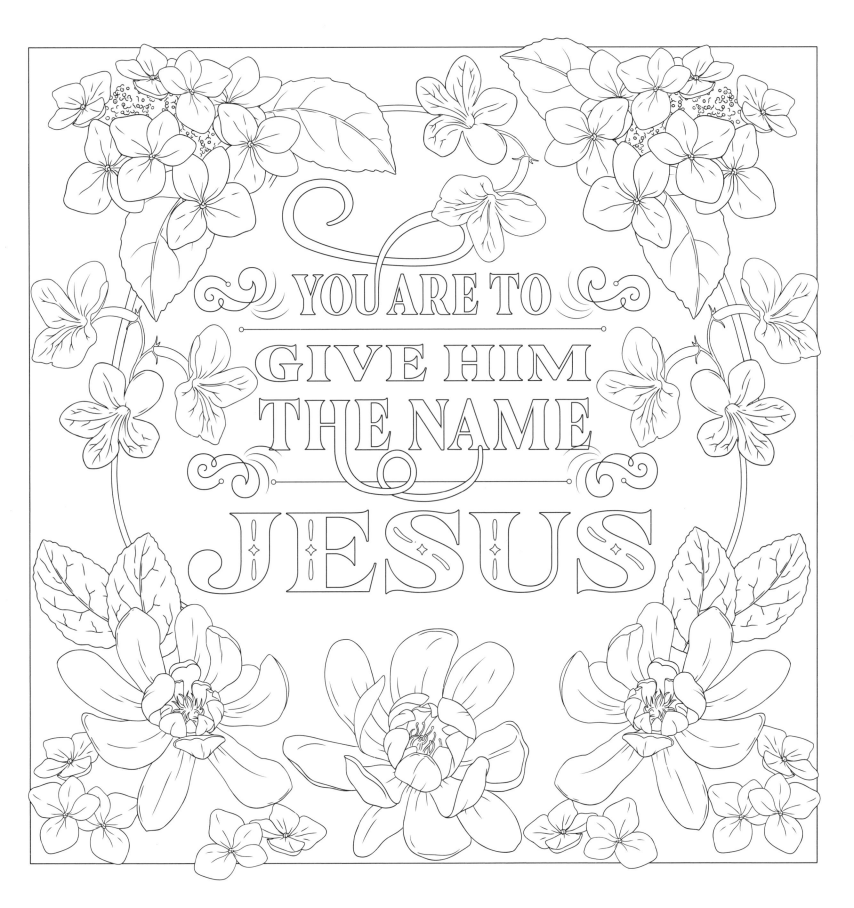

JOSEPH AND MARY

Though one may be overpowered, two can defend themselves. A cord of three strands is not quickly broken.

ECCLESIASTES 4:12

As if raising the Son of God weren't enough, Mary and Joseph had to run for their lives from King Herod. They hid in Egypt, far from their lives, their culture, and their family, all to protect the child. Perhaps this was a special time of bonding, as they had only each other and God to rely on. When they returned, they had to care for their other kids and build a family and home.

With so much uncertainty and hardship, it can be hard for any marriage to survive. Sometimes, when we're hurting or struggling, it's tempting to pull back from a relationship and even see our partners as part of the problem. Yet, just as God was with Mary and Joseph, He is with us, too. As Ecclesiastes reminds us, "Though one may be overpowered, two can defend themselves. A cord of three strands is not quickly broken" (Ecclesiastes 4:12).

When God is that third strand in our marriages, we are reinforced by something far beyond our human abilities.

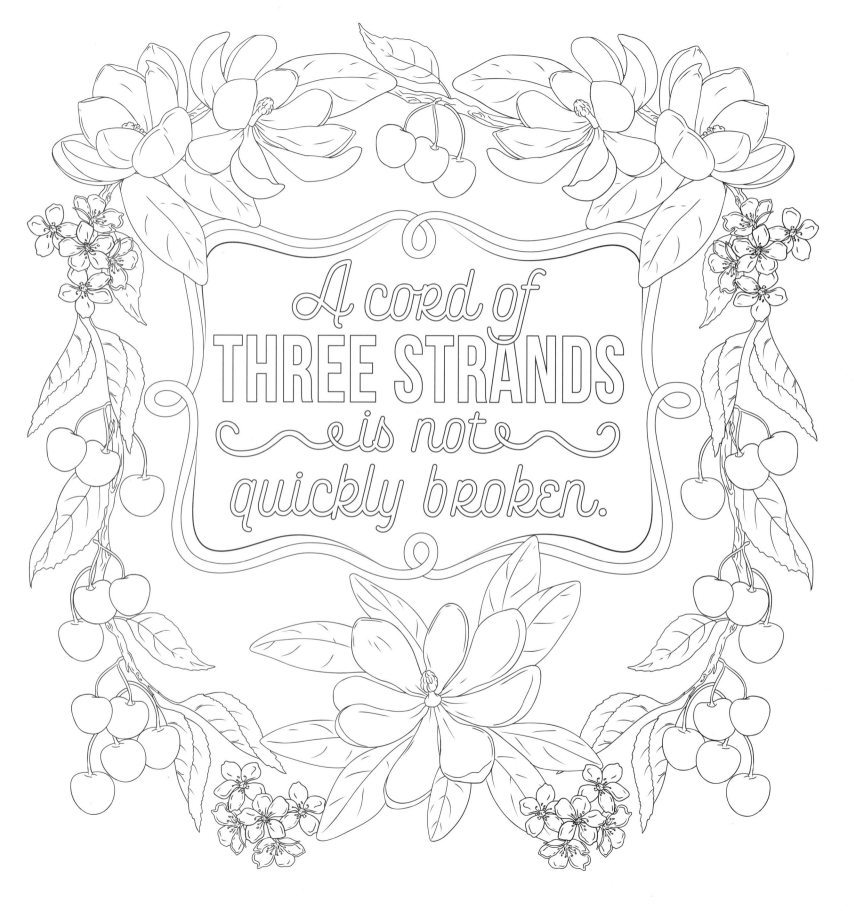

ESTHER AND XERXES

Then Queen Esther answered, "If I have found favor with you, Your Majesty, and if it pleases you, grant me my life—this is my petition. And spare my people—this is my request...."

ESTHER 7:3

Sometimes it's tempting to reduce the story of King Xerxes and Esther to a modern rom-com. But this isn't a sugary rags-to-riches tale; it's much deeper than that! The book of Esther reveals God's divine work in a less-than-ideal marriage. When we first meet King Xerxes, he's arrogant and impulsive, dismissive of women. Yet, through their story together, the king grows in appreciation of Esther and her courage until he meets his wife's greatest desire in her most vulnerable moment of need and saves the Jewish people.

King Xerxes and Esther remind us that God can still work through two imperfect people who don't always see eye to eye. Plenty of godly women find themselves in marriages with husbands who don't share their faith, but that doesn't mean God can't work mightily through them.

A faithful woman can change the course of history, whether her spouse is a spiritual leader or not.

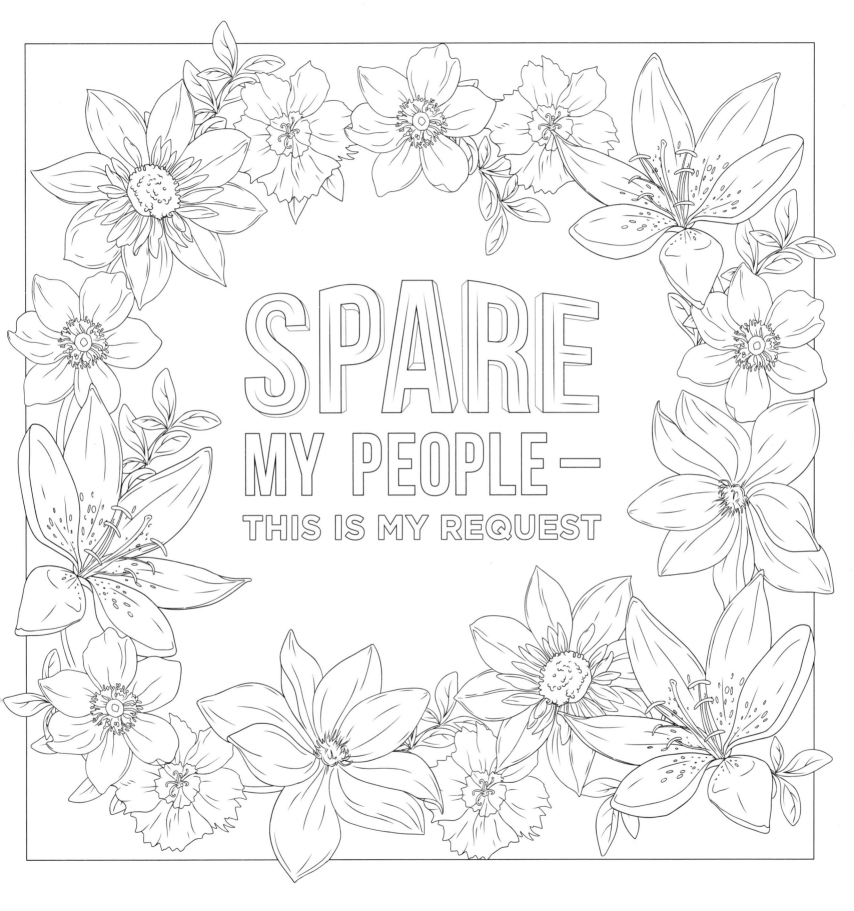

RUTH AND BOAZ

And we know that in all things God works
for the good of those who love him,
who have been called according to his purpose.

ROMANS 8:28

Boaz, a wealthy landowner, shows generosity and hospitality to Ruth, a Moabite widow who is gleaning in his fields. Ruth, in turn, shows her loyalty to her mother-in-law, Naomi, and her faith in God. Their love story doesn't start with lightning or a love-at-first-sight moment. It unfolds as they are moved by the character and integrity that they recognize in each other. They act in honorable ways toward each other and others. Together, they provide an inspiring example of a healthy, loving relationship and remind us that the best love is always founded in God.

Their love for each other was rooted in their love for God,
characterized by selflessness and generosity.

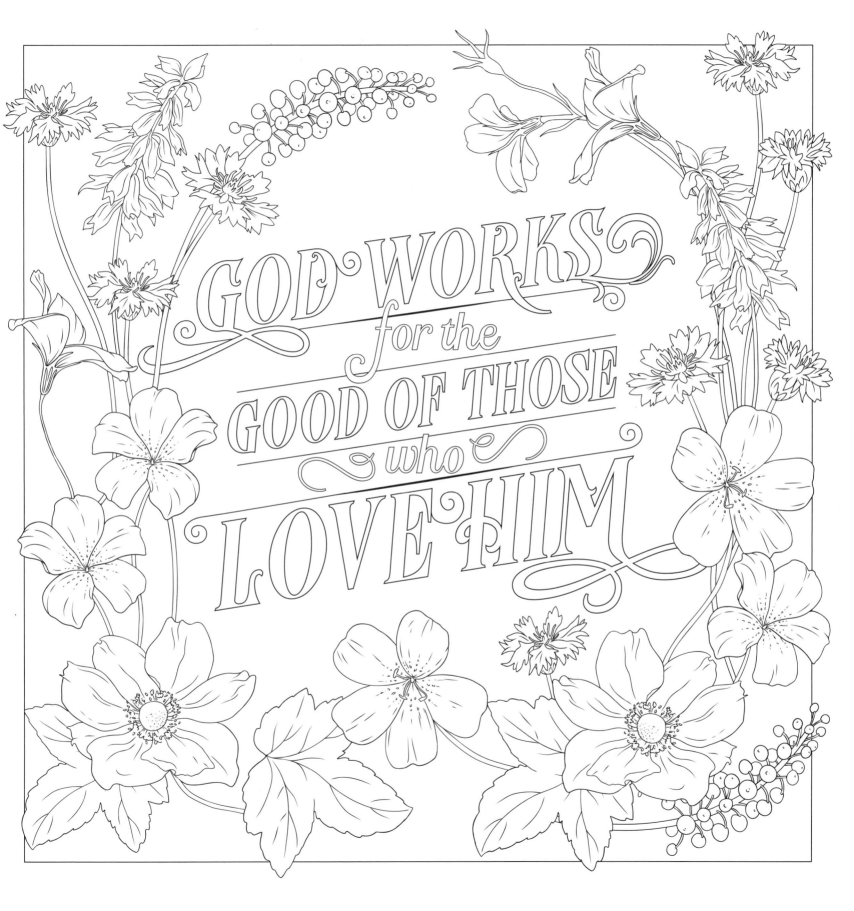

DAVID AND ABIGAIL

*She bowed down with her face to the ground and said,
"I am your servant and am ready to serve you and
wash the feet of my lord's servants."*

1 SAMUEL 25:41

On the run from King Saul, David respectfully sends a request for food and supplies to a rich man named Nabal, whose name means "fool." Nabal refuses and responds harshly, but his wife, Abigail, intervenes. She gives David the exact opposite response of Nabal and shows David respect and honor. After Nabal's sudden and unexpected death, David asks Abigail to become his wife. Their love story reminds us that God is the God of second chances. The Lord can take what the enemy intends for evil and turn it into good (Genesis 50:20). He certainly did that for Abigail, and He will for you, too.

*We are not powerless in the midst of trouble. You equip and guide us.
You are the God of second chances.*

DAVID AND JONATHAN

*After David had finished talking with Saul,
Jonathan became one in spirit with David,
and he loved him as himself.*

1 SAMUEL 18:1

Just as a love story can seem like a match made in heaven, our friendship stories can, too. One of the greatest friendship stories in the Bible is also one of the least likely. Jonathan and David can't be more different. Jonathan is a prince, while David is a shepherd. As the king's son, Jonathan has position, power, and sleeps in a palace, while David has a slingshot and sleeps outdoors. After David topples Goliath, rather than becoming jealous of David's success, Jonathan's appreciation and respect for him grows. Jonathan even goes against his father and saves David's life when Saul tries to kill him. Together, they challenge us to become better, more loving, and more loyal to others.

*In David and Jonathan's friendship we see two people vowing
to have each other's backs in very difficult circumstances—
not because of obligation but by choice.*

JONATHAN BECAME ONE IN SPIRIT WITH DAVID

LONG-LASTING FRIENDSHIPS

"Don't be afraid," David said to him, "for I will surely show you kindness for the sake of your father Jonathan. I will restore to you all the land that belonged to your grandfather Saul, and you will always eat at my table."

2 SAMUEL 9:7

When Jonathan discovers David's life has been endangered by King Saul, the two couldn't separate without a goodbye. But David takes a great risk to thank his closest friend. They weep together and pledge their friendship forever—even through their descendants (1 Samuel 20:41–42). Years later, after Jonathan dies and David becomes king, David remembers their pledge. He finds one of Jonathan's descendants, Mephibosheth, who is unable to walk. King David gives him all the land that Saul once owned and assigns workers to bring in the bounty. David even has Mephibosheth sit at the king's table like a royal son. David and Jonathan teach us that the gift of friendship can last beyond a lifetime.

The Bible beckons us to recognize the wonder, the miracle that is true, covenanted friendship-love.

DEEP FRIENDSHIPS

I grieve for you, Jonathan my brother; you were very dear to me. Your love for me was wonderful, more wonderful than that of women.

2 SAMUEL 1:26

When David hears of Jonathan's death in battle, he mourns through a song whose verses remain among the most heartbreaking and vulnerable in all of Scripture. "I grieve for you, Jonathan my brother; you were very dear to me. Your love for me was wonderful, more wonderful than that of women" (2 Samuel 1:26). In saying this, David compares his friendship with Jonathan to God's biggest miracles. The Hebrew word for "love" is *ahavah*, and it describes God's love toward us. David pairs this with "wonderful," the same word that's used to describe God's remarkable miracle of striking down the Egyptians (Exodus 3:20) and the parting of the Jordan River (Joshua 3:5). God works all kinds of wonders—including giving us the gift of beloved friends.

In giving us the example of David and Jonathan, the Bible calls to honor the love of friendship.

DANIEL AND FRIENDS

Then the king ordered Ashpenaz, chief of his court officials, to bring into the king's service some of the Israelites from the royal family and the nobility . . .

DANIEL 1:3

King Nebuchadnezzar captures Jerusalem and forces the best and brightest into his service. Their royal training focuses on language, literature, and food—undermining what made the men distinctly Jewish. Daniel asks the royal official if he and his three friends, Shadrach, Meshach, and Abednego, can eat vegetables and drink water rather than partake of the royal diet of meat and wine. Afterward, they are stronger and healthier than those who ate the king's food. Their friendship and commitment to God are strengthened, and they remind us that though we can't always escape where we are in life, we can choose how we respond. We can turn to our faith, friends, and God even when we can't change our circumstances.

They knew it was far better to obey God's commands than give in to the seductive luxuries of Babylon.

SHADRACH, MESHACH, AND ABEDNEGO

Then Nebuchadnezzar said, "Praise be to the God of Shadrach, Meshach and Abednego, who has sent his angel and rescued his servants! They trusted in him and defied the king's command and were willing to give up their lives rather than serve or worship any god except their own God...."

DANIEL 3:28

Shadrach, Meshach, and Abednego proudly use their Jewish names: Hananiah, meaning "the grace of God," Azariah, meaning "the help of God," and Mishael, meaning "who is like the Mighty One?" Together, they refuse to bow to King Nebuchadnezzar's giant golden statue. They tell the king that their God is able to spare them from the fiery furnace—but even if God does not, they will not bow. They are willing to die together. Though the furnace's back draft alone is so intense that it kills the men who bring them to the furnace, when the trio emerges from the furnace, they don't even smell like smoke. These devoted friends teach of the power of support and encouragement in the trials of life, demonstrating a deep and enduring friendship.

What a gift God gives us when He blesses us with courageous brothers and sisters committed to standing in unity when trials come!

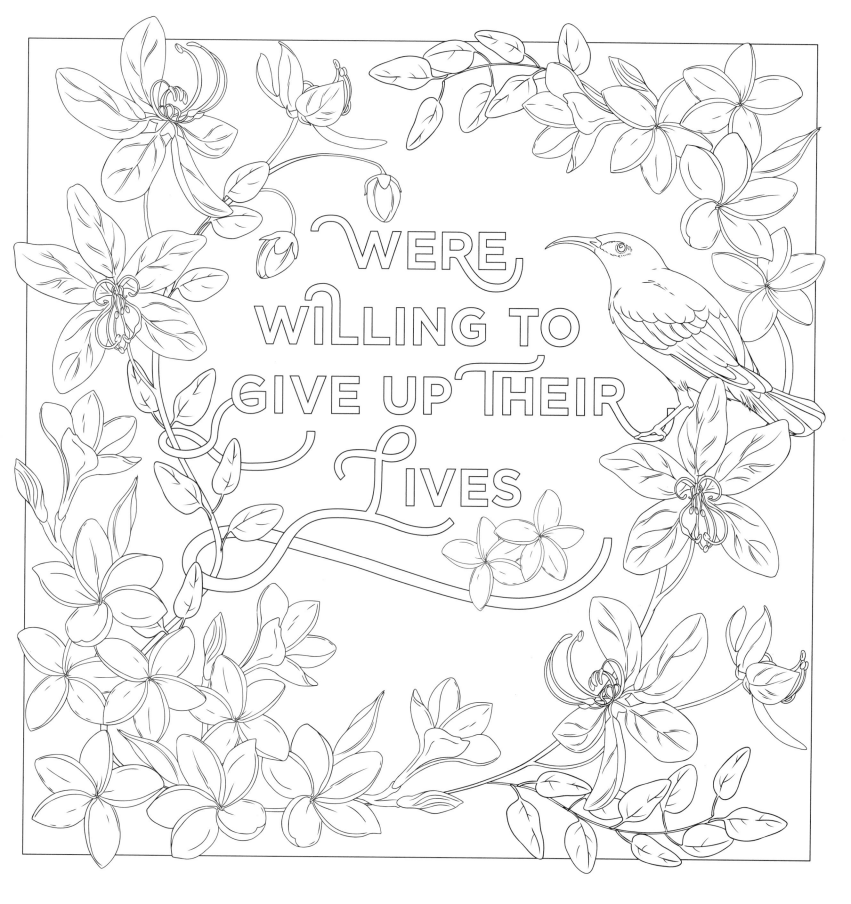

WERE WILLING TO GIVE UP THEIR Lives

LOVE

And now these three remain: faith, hope and love.
But the greatest of these is love.

1 CORINTHIANS 13:13

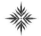

Though often read at weddings, 1 Corinthians 13 gives us a blueprint for loving others well no matter what the relationship. The first few verses tell us that apart from love, most of what we do is worthless, empty, and meaningless. Even if we have great spiritual gifts, if they are expressed without love, they're still hollow and pointless no matter how noisy or impressive. True love, whether expressed through romance, family, or friendships, refuses to give up, puts others before self, and takes pleasure in truth. True love always trusts, never looks back, and keeps going to the very end. This kind of love never fails. Indeed, love "always protects, always trusts, always hopes, always perseveres" (1 Corinthians 13:7). This is the love we're meant to receive from God and pour out in every relationship.

If we are operating from anything less than the purest motivations of love, we might as well have stayed home on the couch, eating bonbons.

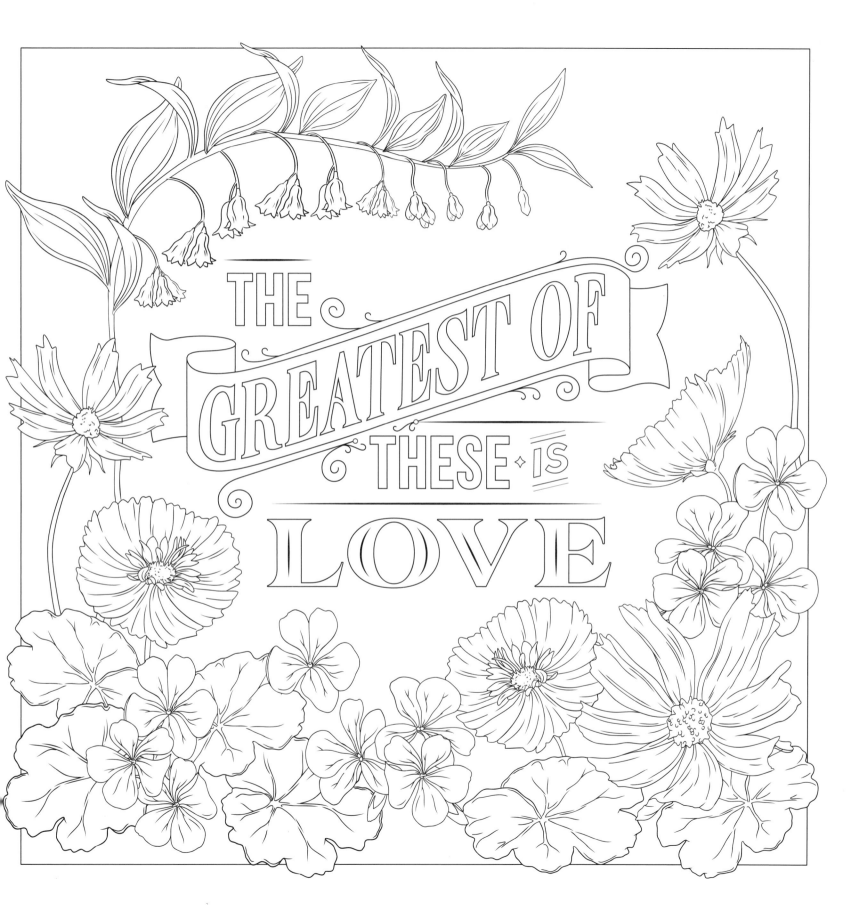

AN UNLIKELY FRIENDSHIP

But the Lord said to Ananias, "Go! This man is my chosen instrument to proclaim my name to the Gentiles and their kings and to the people of Israel...."

ACTS 9:15

Ananias has heard all the stories of how Saul persecuted believers. So when God instructs Ananias to visit Saul, Ananias raises a hefty concern. Yet the Lord assures Ananias, "Go! This man is my chosen instrument" (Acts 9:15). Through Ananias's obedience, the scales fall from Saul's eyes. Not only does Saul regain his physical sight, he regains his spiritual sight, too. Ananias's willingness to trust God results in a once hunter of believers becoming one of Jesus's greatest advocates. Even more sweetly, Ananias becomes Saul's first Christian friend, reminding us that sometimes the people we resist can become our greatest partners, allies, and companions.

God sent Ananias to help Saul launch his wide-reaching mission to spread the Gospel.

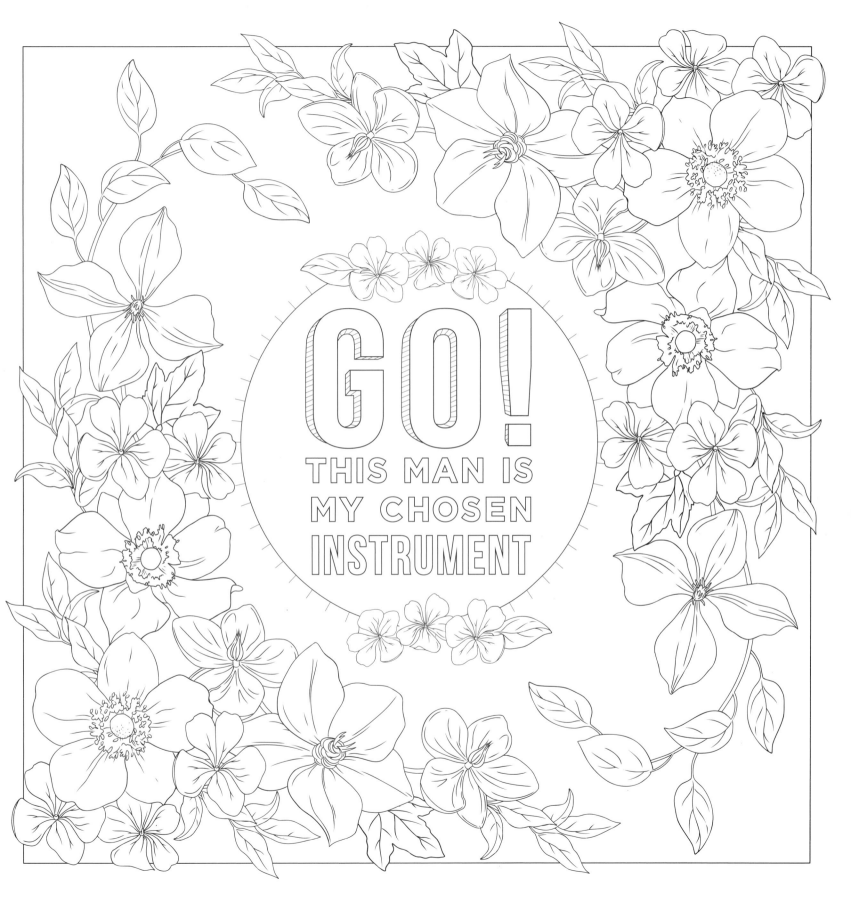

GO! THIS MAN IS MY CHOSEN INSTRUMENT

BRIDGE-BUILDING FRIENDS

So Saul stayed with them and moved about freely in Jerusalem, speaking boldly in the name of the Lord.

ACTS 9:28

Though Saul has become a passionate follower of Jesus, the disciples aren't convinced at first. They are afraid Saul hasn't really changed, and when he shows up in Jerusalem, the disciples make sure to keep their distance from him. Yet Barnabas becomes an advocate for Saul. He takes Saul to them and shares how Saul has preached fearlessly in Damascus. Then they welcome Saul and "Saul stayed with them" (Acts 9:28). Barnabas's friendship with both parties makes him a bridge-builder and gives us an example of the importance of having friends who will advocate and vouch for us and the importance of being that kind of friend, too.

Are you willing to spend some of your social capital in order to make sure an unknown companion gets a fair shake in an unfamiliar situation?

FRIENDSHIPS FOR THE JOURNEY

Be devoted to one another in love.
Honor one another above yourselves.

ROMANS 12:10

After Saul (now called Paul) becomes a believer, he crisscrosses the Mediterranean region, bringing the good news of Jesus. Many of his trips are harrowing adventures marked by risk, peril, and uncertainty. It's easy to imagine Saul overcoming shipwrecks, imprisonment, and beatings—just him and God. But his missionary journeys were not made alone.

Saul has friends and colleagues who support him through their friendship, financial support, and companionship. On each venture, he takes along at least one other friend. Saul teaches us that early Christianity was built on a flourishing network of believers, who often became friends, and that our faith was never meant to be a solo journey.

Friendship was the engine of the early Church.

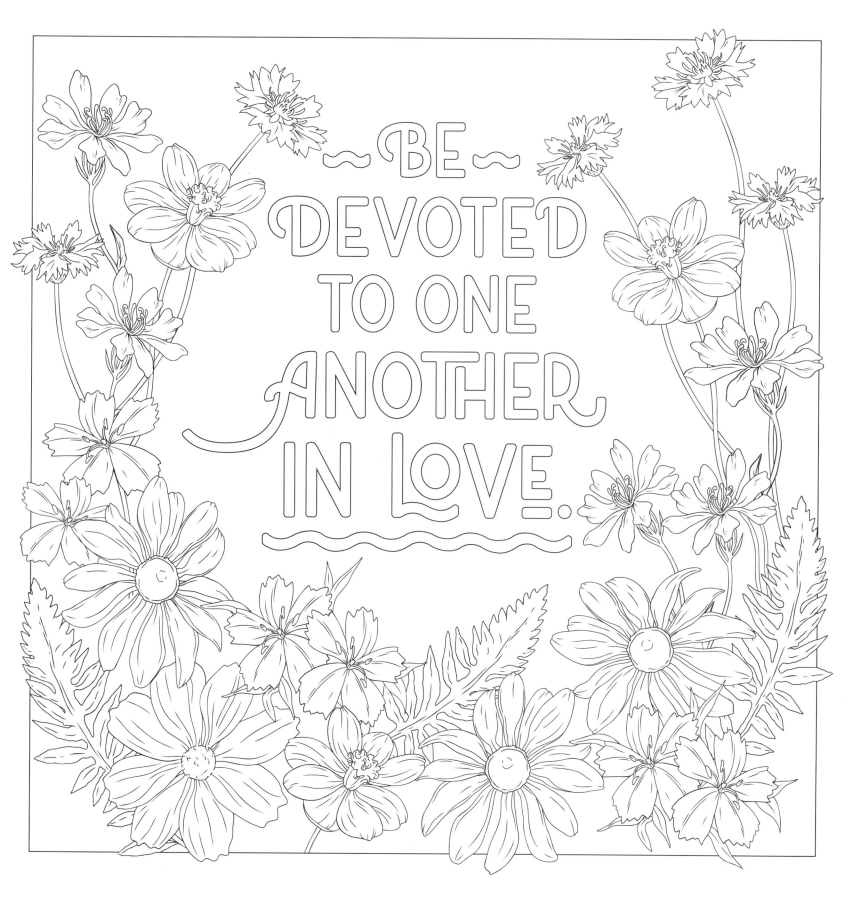

PAUL'S FRIENDSHIPS

And over all these virtues put on love,
which binds them all together in perfect unity.

COLOSSIANS 3:14

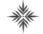

Paul makes friends almost everywhere he travels as he encourages people in the faith. These include Aquila, Priscilla, Epaphras, Tychicus, Apphia, Zenas the lawyer, Aristarchus, Archippus, and so many others. Paul often writes letters to those who are dear to him, including Timothy, who is like a spiritual son, and Titus, who helps with the church at Corinth when it hits tough times. The disciple Luke, along with Silas, travels to Rome with Paul on his final journey.

God often uses our friendships to equip us for the tasks He has designed for us. They are a powerful source of help, strength, and encouragement, and a reminder of God's great provision and love for us. Like Paul, we all need friendships to fulfill our purposes on this earth.

What a beautiful network of support Paul had
in the midst of a demanding ministry.

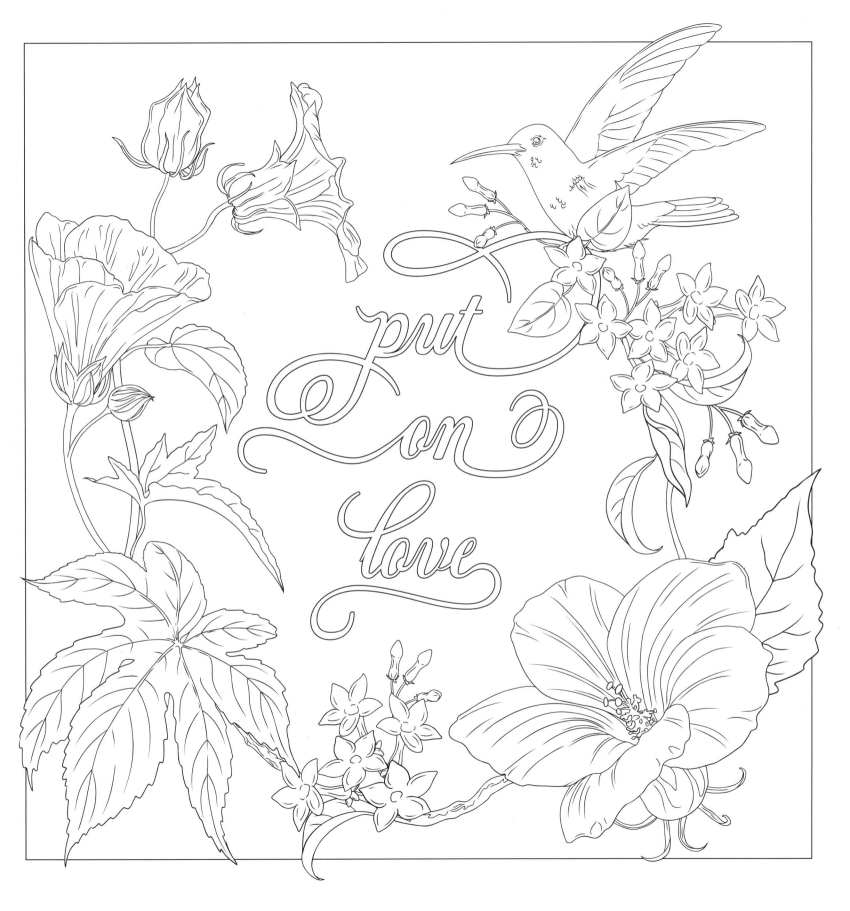

put on love

ONESIMUS

I am sending him—who is my very heart—back to you.

PHILEMON 1:12

Paul likely got to know Onesimus while he was under house arrest in Rome. Though Onesimus is a slave, Paul sees Onesimus as a precious human made in the image of God. Onesimus accepts Christ and becomes a spiritual son to Paul. This is revolutionary for the time, because slaves in antiquity were not seen as legal people. They couldn't own property or give testimony in court. Yet Paul calls Onesimus a "fellow man" and "brother in the Lord" (Philemon 1:16) as well as something special and tender, "my very heart" (Philemon 1:12).

In Philemon, Paul crafts a carefully worded, diplomatic letter to fight for his friend's freedom. Paul teaches us that true friendship, like unending love, finds its beginning, end, and purpose in Jesus.

Paul shows us that when we share Jesus with someone we love, that bond becomes unbreakable.

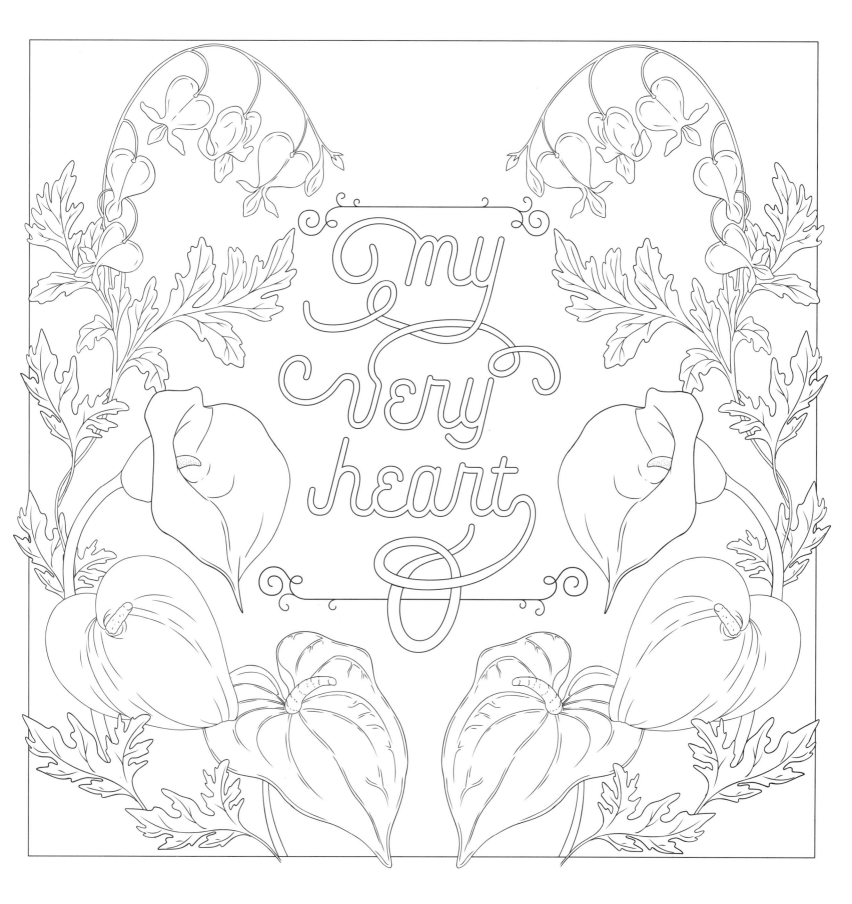

THE GIFT OF PRESENCE

Then they sat on the ground with him for seven days and seven nights. No one said a word to him, because they saw how great his suffering was.

JOB 2:13

Friends are gifts from God in every season of life, but when hardship happens, those who show up and stay for the long haul are some of the most treasured. Job lost nearly everything: his health and wealth, his livestock, and his children. When three of Job's friends, Eliphaz, Bildad, and Zophar, hear the news, they meet together and then come to Job's side to sympathize and comfort him. They follow ancient practices of grieving: ripping their garments, sitting low to the ground, and remaining silent for seven days. As friends, they loved Job by initially refusing to offer empty platitudes or easy explanations. In the beginning of their grieving together, they were simply with him, reminding us that one of the greatest acts of love is to give the gift of our presence.

Looking away from a friend's pain will always be the wrong strategy. Plunge into the anguish with them. Just show up.

ELIPHAZ

In all this, Job did not sin by charging God with wrongdoing.

JOB 1:22

Of Job's three friends, Eliphaz is the first to speak to Job. Though he probably had good intentions, Eliphaz assumes he knows why Job has suffered. When he says, "Consider now: Who, being innocent, has ever perished?" (Job 4:7), Eliphaz suggests that Job brought calamity on himself because of his sinfulness. He thinks he is helping Job by pointing out the error of his ways, but his words are cruel and untrue. We can never presume to know why a person is suffering. The best thing we can do is simply love, serve, and encourage them in their journeys.

Job was actually targeted by the enemy and living through this anguish precisely because God had pointed out just how upright Job was.

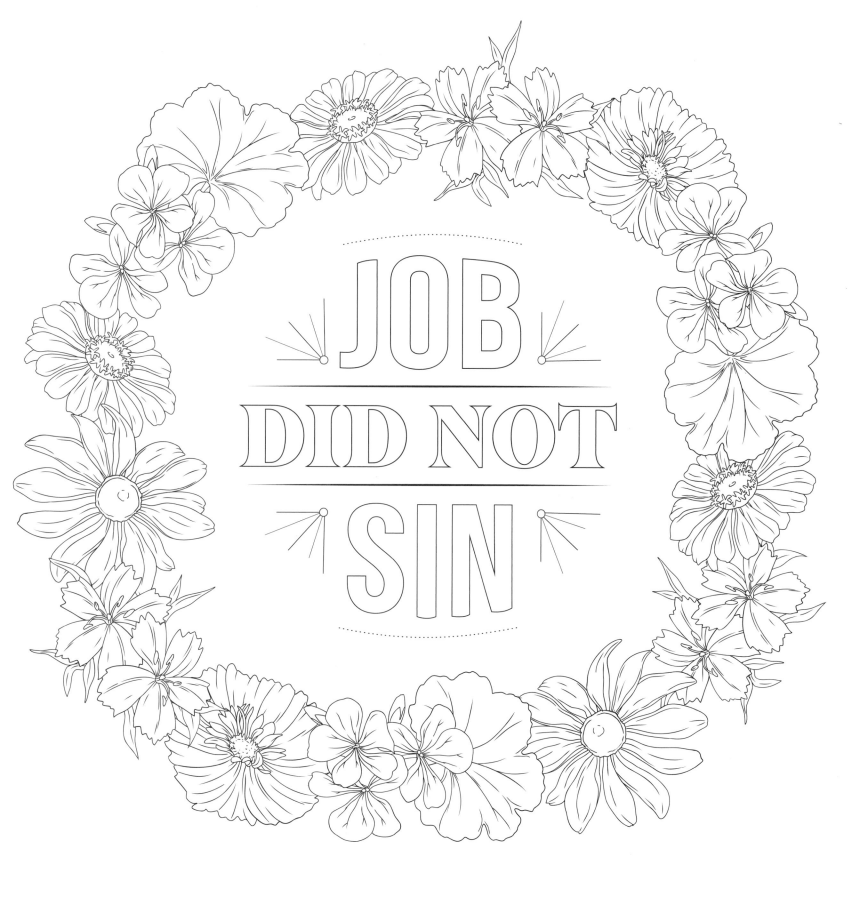

JOB
DID NOT
SIN

ZOPHAR

"To God belong wisdom and power; counsel and understanding are his...."

JOB 12:13

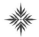

Sometimes friends don't know how to provide the emotional support we need in our moments of pain and loss. Rather than provide encouragement, Zophar responds to Job's pain with accusation and anger. Zophar attacks Job: "You say to God, 'My beliefs are flawless and I am pure in your sight.' Oh, how I wish that God would speak, that he would open his lips against you" (Job 11:4–5). Yikes! Zophar wants Job to be reprimanded by God. In response, Job suggests we can never fathom the mind and mysteries of God. Zophar's response challenges us to always respond to others' suffering with loving-kindness, patience, and compassion.

We are not prepared to understand the inscrutable mystery of God's personhood because we are too weak to hold His awesomeness in our minds, no matter how wise we think we are.

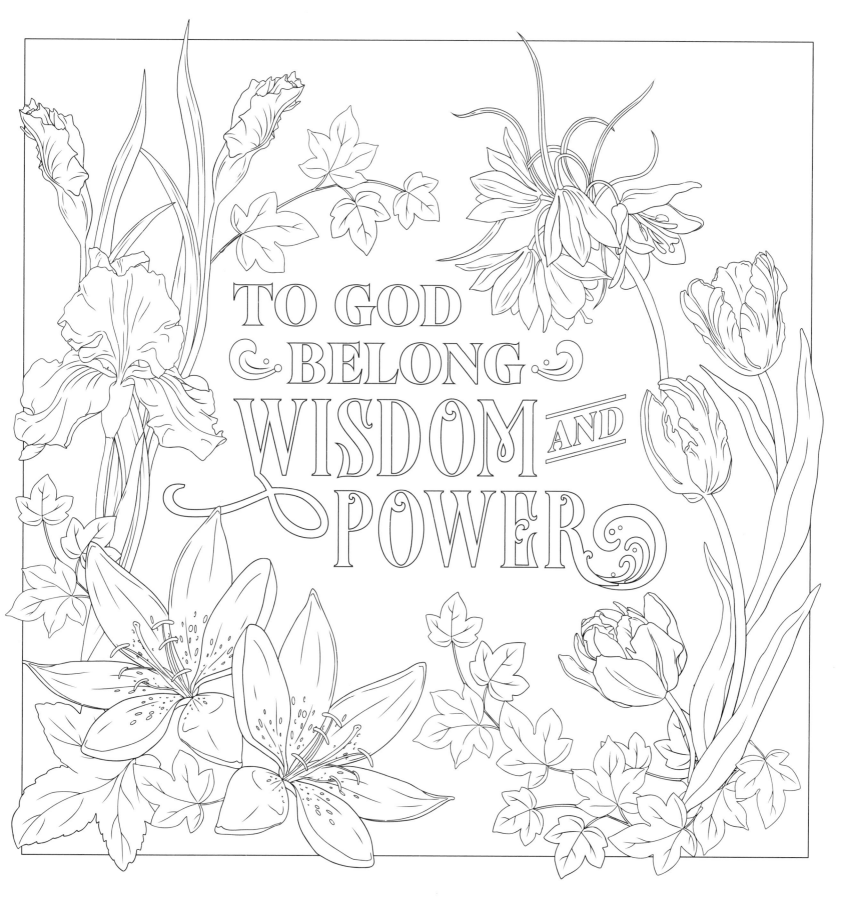

TO GOD BELONG WISDOM AND POWER

PRAYERFUL FRIENDSHIPS

"... So now take seven bulls and seven rams and go to my servant Job and sacrifice a burnt offering for yourselves. My servant Job will pray for you, and I will accept his prayer and not deal with you according to your folly. You have not spoken the truth about me, as my servant Job has."

JOB 42:8

Eliphaz, Bildad, and Zophar remind us that none of us are perfect and at times we fumble at trying to love and comfort others. Much of what this trio say to Job is inaccurate, but they still show up and stay for the long haul. In the end, God spoke with authority in defense of Job. The three friends are instructed to make a sacrifice of burnt offerings and then have Job intercede for them. They obey, and the Lord accepts Job's prayer. Job teaches us the power of intercession and praying for our friends—and how genuine friendships can heal and recover from the storms of life.

It's the courage to actually show up and engage that defines a solid friendship.

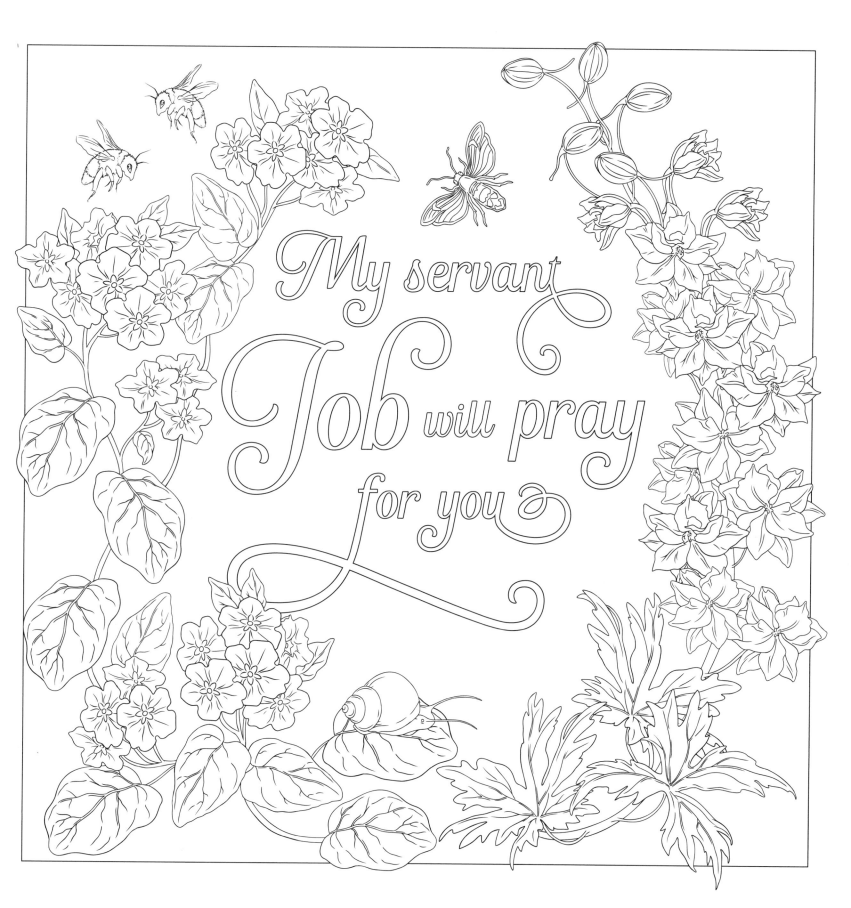

My servant Job will pray for you

JESUS'S FRIENDSHIPS

I no longer call you servants, because a servant does not know his master's business. Instead, I have called you friends, for everything that I learned from my Father I have made known to you.

JOHN 15:15

God designed us to experience and enjoy vibrant friendships. We were created to live in community with others, and Jesus demonstrates this throughout His life. Though He could have gone on the journey alone, Jesus spends His years of ministry with friends and family members. He hikes hundreds of miles, travels in fishing boats, and shares unforgettable meals with a wide range of companions. Some of His closest friends are the disciples, with whom He faces wild storms, sharp rejection, and intense exhaustion. Yet those stressors fortify rather than fray their friendship. If Jesus was God, and He had tight-knit friends, how much more should we nurture and celebrate our friendships, too?

His relationships speak just as eloquently about His nature.
He was God, and He had close friends.

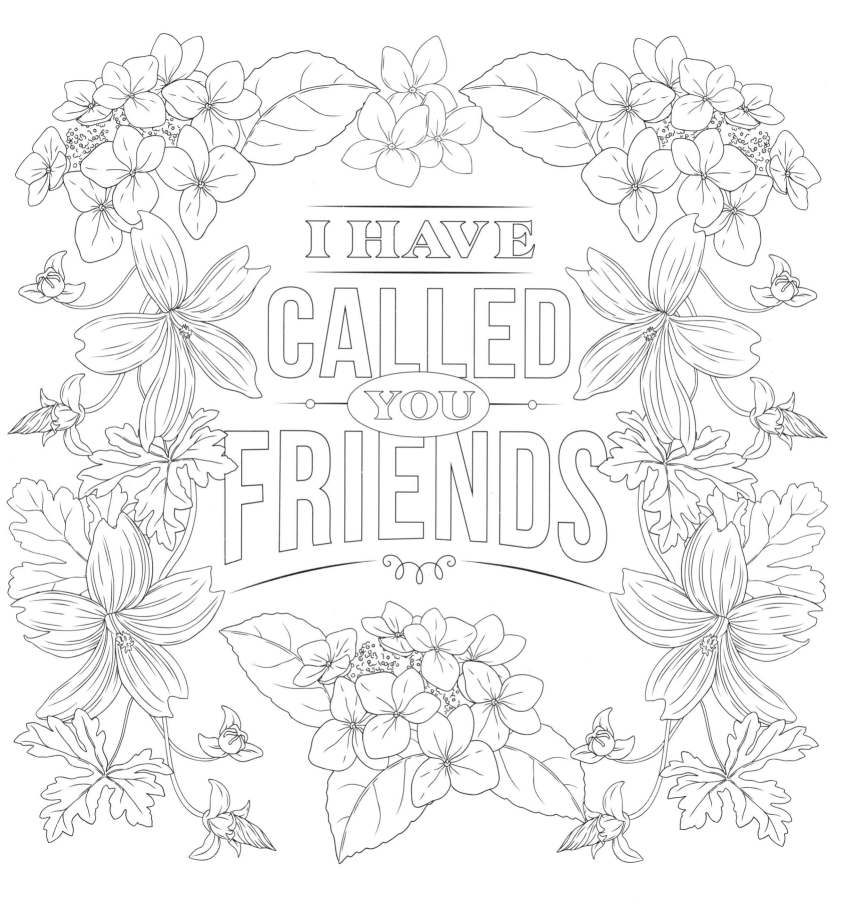

I HAVE CALLED YOU FRIENDS

THE DISCIPLE JESUS LOVED

*Dear friends, let us love one another,
for love comes from God. Everyone who loves
has been born of God and knows God.*

1 JOHN 4:7

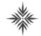

Of all the disciples, many scholars believe John was Jesus's closest friend. In his Gospel, John describes himself as "the disciple whom Jesus loved" four times. This wasn't meant to be haughty but rather a confession that his identity was wholly and securely found in Christ.

During the course of their friendship, Jesus's love transforms John. He goes from being a hothead known as one of the "Sons of Thunder" to one who can't stop preaching and teaching on the love of God. He writes, "Dear friends, let us love one another, for love comes from God. Everyone who loves has been born of God and knows God" (1 John 4:7). Just as John was transformed by his friendship with Jesus, so we should be, too.

**That's also what our human friendships should do:
encourage each other to be more like Christ.**

HOSEA AND GOMER

The Lord said to me, "Go, show your love to your wife again, though she is loved by another man and is an adulteress. Love her as the Lord loves the Israelites, though they turn to other gods and love the sacred raisin cakes."

HOSEA 3:1

Hosea was a prophet commanded by God to marry a promiscuous woman named Gomer. The marriage was a symbolic representation of God's relationship with Israel, who had repeatedly turned away from Him, worshipped false gods, and pursued self-indulgent pleasures. Despite Gomer's unfaithfulness, God instructs Hosea to love her and take her back even when she is sold into slavery. He specifically tells Hosea to "Love her as the Lord loves" (Hosea 3:1).

The story illustrates the depth of love and sacrifice necessary in relationships. Hosea's love for Gomer requires him to endure pain and suffering, just as God's love for us is demonstrated through the sacrifice of His son, Jesus Christ. The prophetic story of Gomer and Hosea reminds us of God's incredible love and the lengths He will go to bring us back into a relationship with Him.

While Gomer was unfaithful to her husband,
as the people of Israel were unfaithful to the Lord,
Hosea made the difficult choice to abide in God's plan.

ULTIMATE LOVE

This is love: not that we loved God, but that he loved us and sent his Son as an atoning sacrifice for our sins.

1 JOHN 4:10

The love of God is one of the most wondrous and magnificent gifts in all creation. It defies human understanding. God's affection transcends time and space, reaching down from the heavens to embrace us with its gentle warmth and unyielding grace. With every beat of our hearts, we are reminded of this love, of its infinite depth and its boundless compassion.

First John 4:10 says, "This is love: not that we loved God, but that He loved us and sent His Son as an atoning sacrifice for our sins." This verse is a testament to the selflessness and generosity of God's love, a love that is waiting to scoop you up today. Through Jesus Christ, you can experience the transformative power of God's love . . . and its ability to heal wounds and bring you into a new and abundant life.

Love. Grace. Mercy.
These aren't just things God gives us.
They are who He is.

GOD'S UNCONDITIONAL LOVE

See what great love the Father has lavished on us,
that we should be called children of God!
And that is what we are! The reason the world does
not know us is that it did not know him.

1 JOHN 3:1

So much of life comes with condition: if you do this for me, then I'll do that for you. Yet God's love is unconditional. It's not something we need to try to earn; instead, it's given wholly and freely. It's not a force that we can manipulate or control; rather, it's a gift that we must receive with open hands and humble hearts. God's love is not a fleeting emotion but a steadfast commitment that endures through all of life. As 1 John 3:1 affirms, "See what great love the Father has lavished on us, that we should be called children of God! And that is what we are!"

We could never convince a judge or jury we are worthy of God's love,
and thank goodness we don't have to!

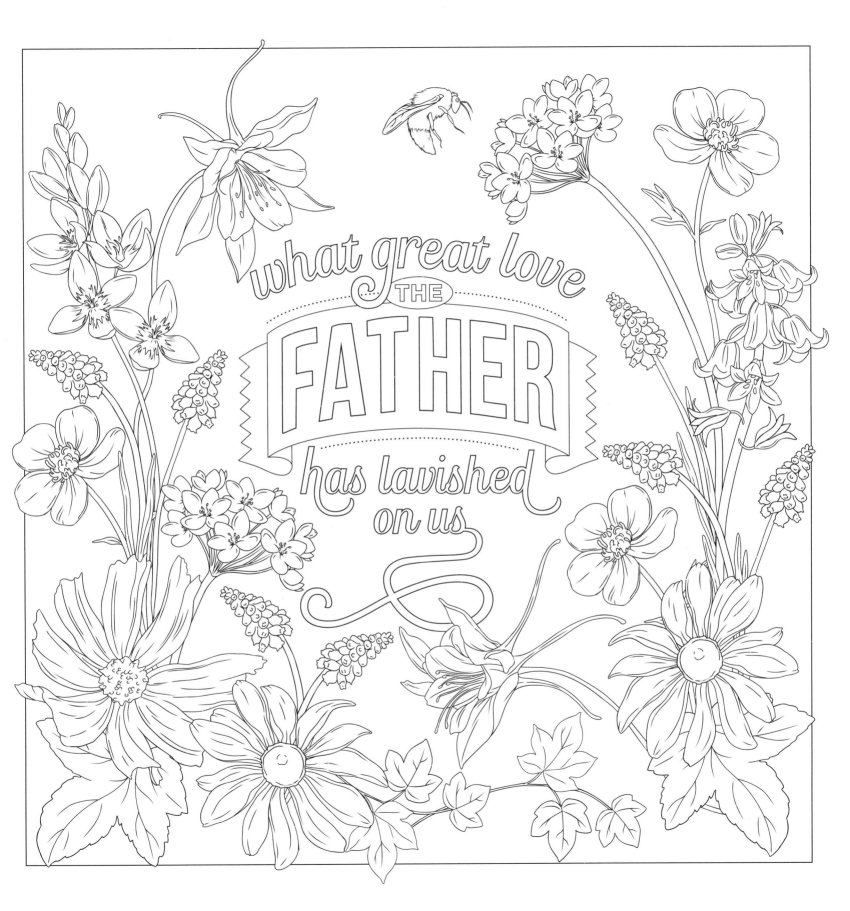

what great love
THE
FATHER
has lavished
on us

SPREADING LOVE

"...The second is this: 'Love your neighbor as yourself.'
There is no commandment greater than these."

MARK 12:31

As those who receive the lavish love of God, we cannot hoard it all for ourselves. God's love is poured into us so it will flow through us. God's unlimited, unconditional, redemptive, merciful love is meant to overflow in our actions and interactions, our attitudes and responses. It should pulse through us everywhere we go. It's why, when Jesus is asked by a religious leader what the single greatest commandment is, Jesus's response is: Love God with everything you've got and love your neighbor as yourself (Mark 12:30–31). The two go hand in hand. Celebrate just how much you're loved by sharing that love with a world that desperately needs it.

Take joy in His adoration of you,
and go make sure others know the good news!

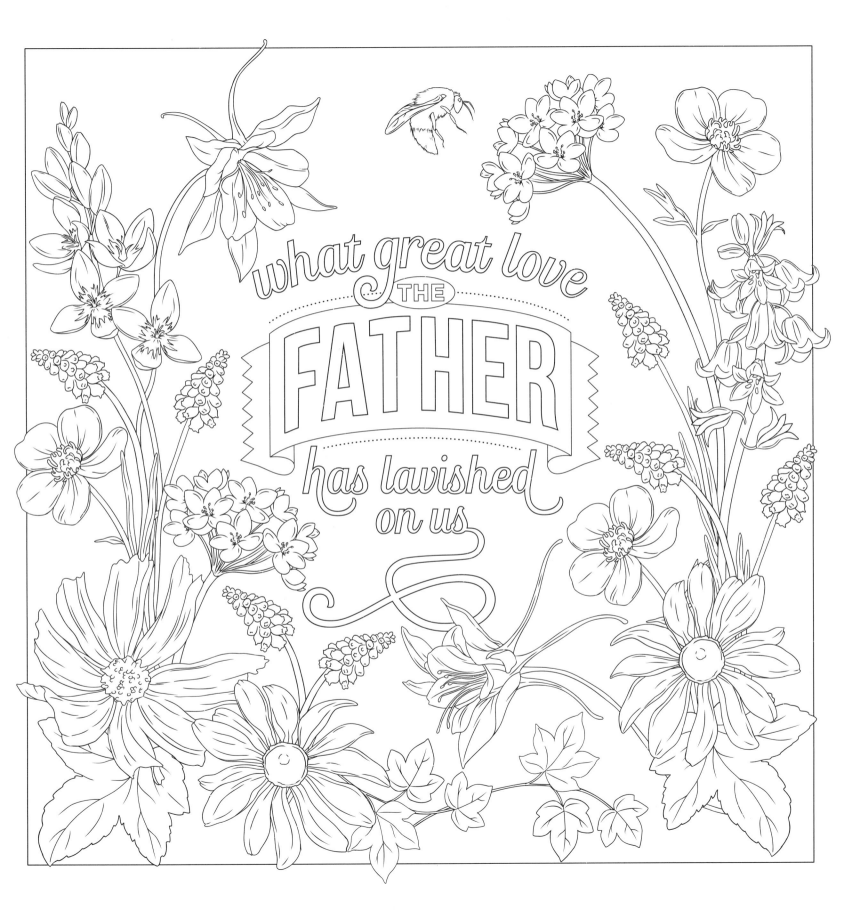

what great love THE FATHER has lavished on us

SPREADING LOVE

"... The second is this: 'Love your neighbor as yourself.'
There is no commandment greater than these."

MARK 12:31

As those who receive the lavish love of God, we cannot hoard it all for ourselves. God's love is poured into us so it will flow through us. God's unlimited, unconditional, redemptive, merciful love is meant to overflow in our actions and interactions, our attitudes and responses. It should pulse through us everywhere we go. It's why, when Jesus is asked by a religious leader what the single greatest commandment is, Jesus's response is: Love God with everything you've got and love your neighbor as yourself (Mark 12:30–31). The two go hand in hand. Celebrate just how much you're loved by sharing that love with a world that desperately needs it.

Take joy in His adoration of you,
and go make sure others know the good news!

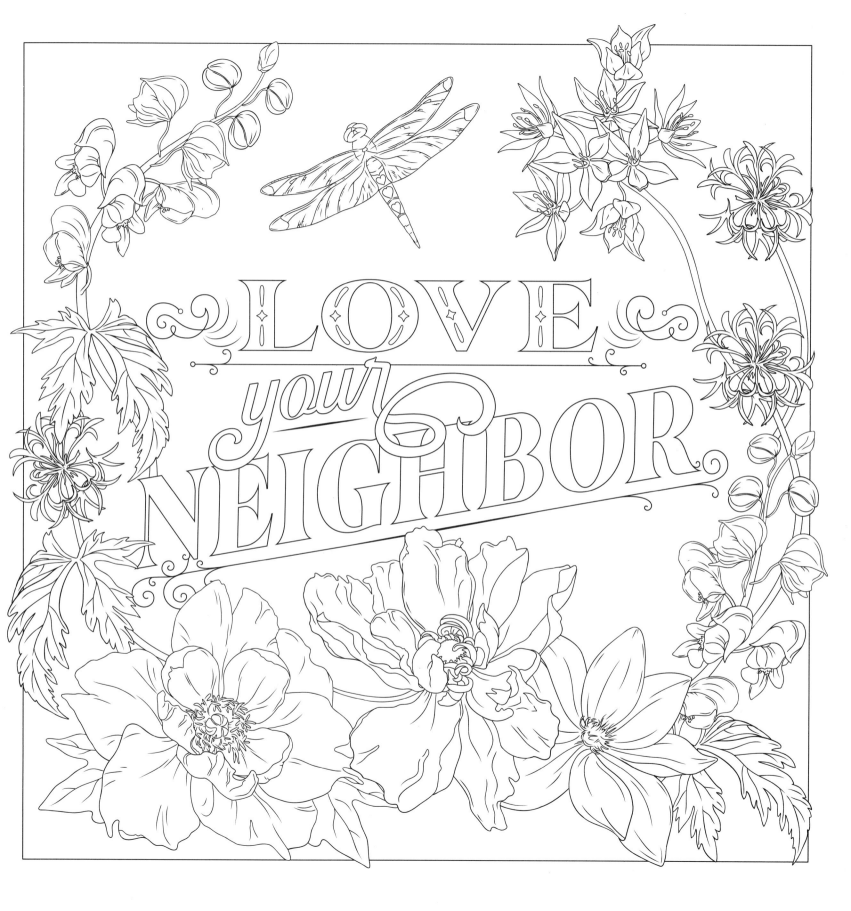

ABOUT THE AUTHOR

SHANNON BREAM is the anchor of *Fox News Sunday*. She is the author of the *New York Times* bestsellers *The Women of the Bible Speak*, *The Mothers and Daughters of the Bible Speak*, and *The Love Stories of the Bible Speak*. Her Fox News Books series on the Bible has sold more than one million copies. She is a chief legal correspondent for Fox News Channel and the host of *Livin' The Bream*, a Fox News Radio podcast. Shannon has anchored a wide variety of coverage for high-profile stories, including presidential elections and key Supreme Court decisions. She earned a Juris Doctorate with honors from Florida State University College of Law and lives in Washington, DC.

ABOUT THE ILLUSTRATOR

AMY JACOBUS is an illustrator, surface designer, and floral designer living in Brooklyn, New York. She earned her Fine Art degree from Parsons School of Design. When not drawing or designing with flowers, she can be found outdoors watching birds and enjoying nature. You can find her on Instagram: @amyjacobusflorals. Amyjacobus.com.